POPULAR TALES

&

MEDIEVAL COLORING BOOK

Copyright © 2015 Randolph Rubicon

All Rights Reserved Worldwide

POPULAR TALES
Coloring Book

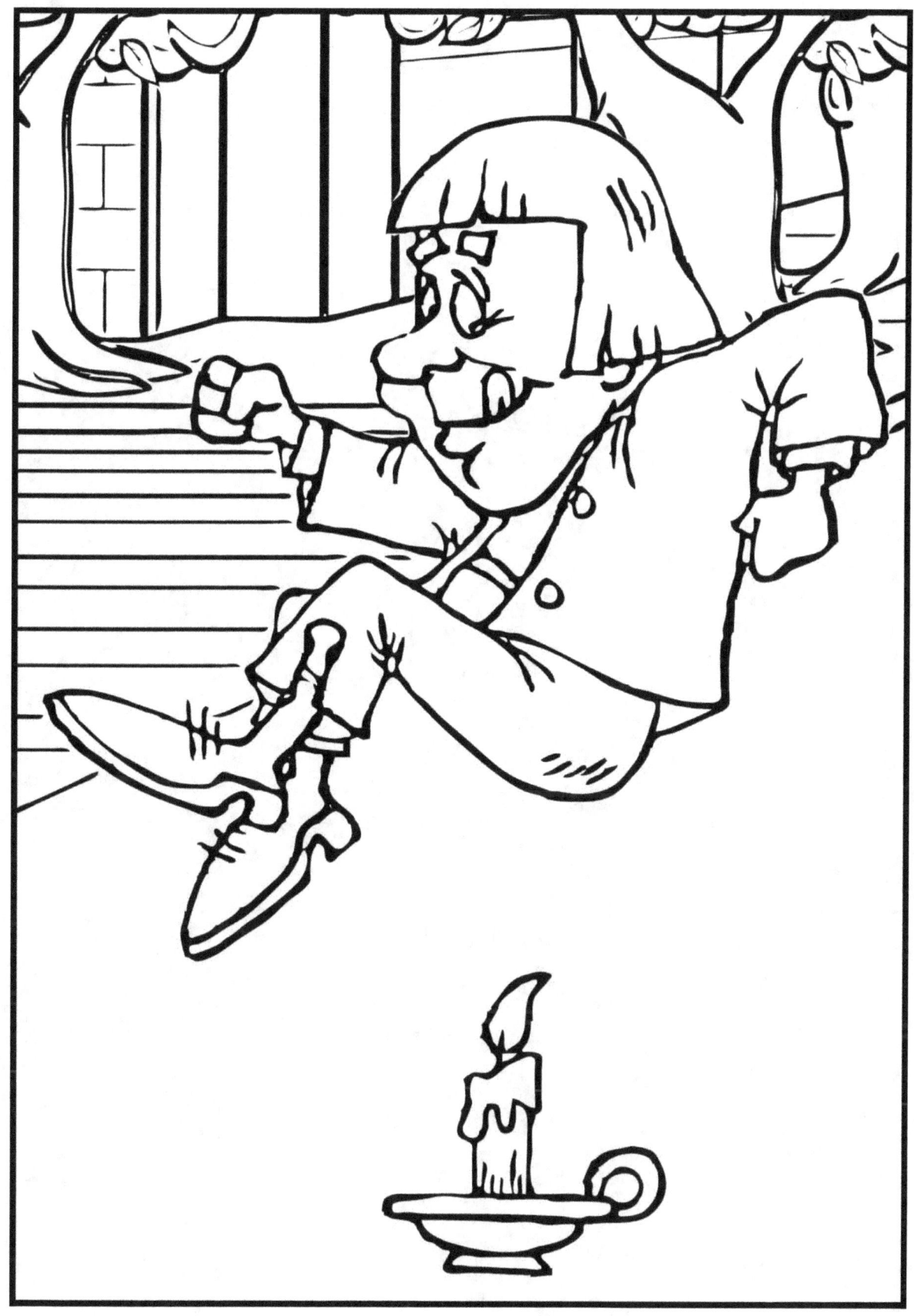

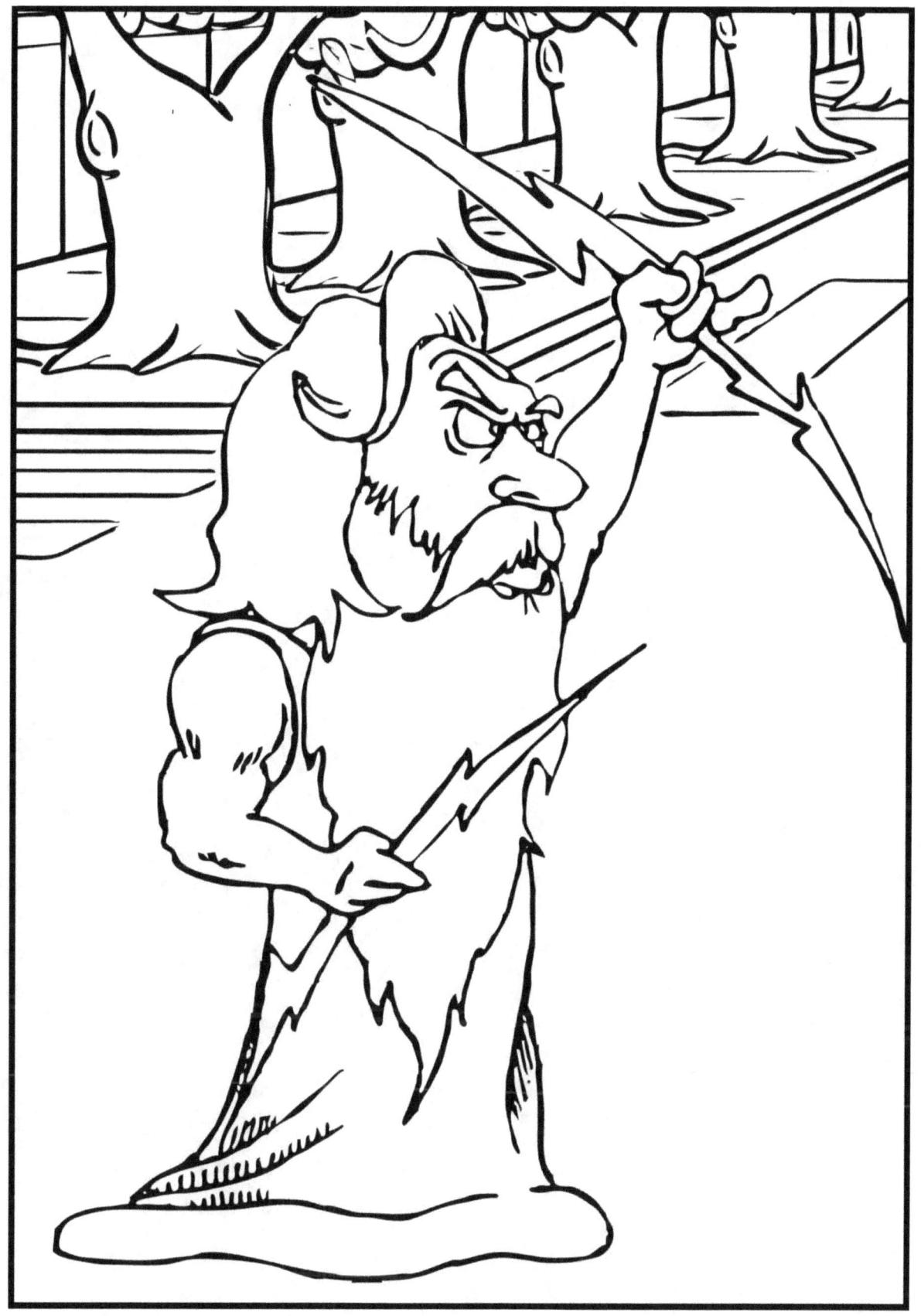

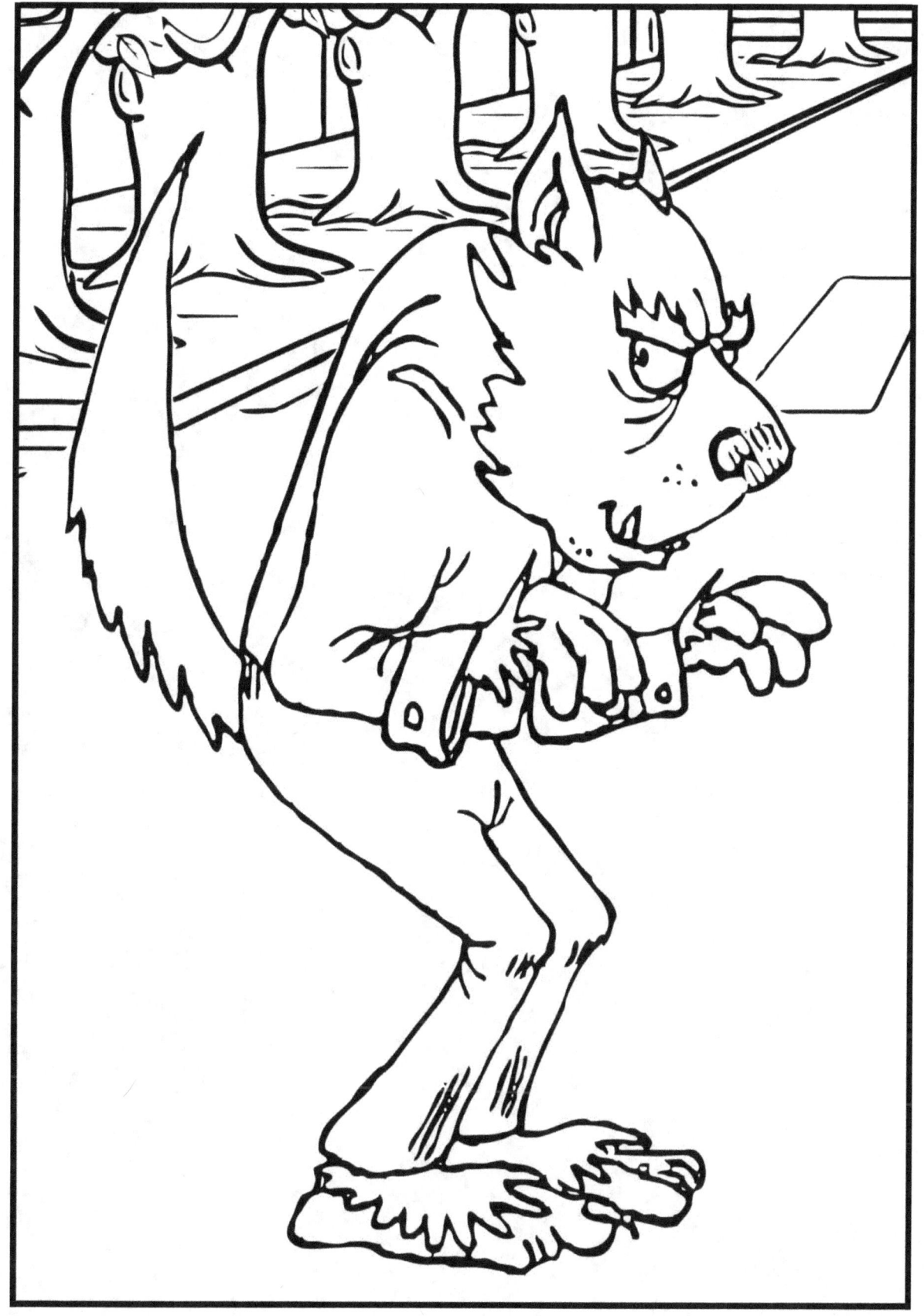

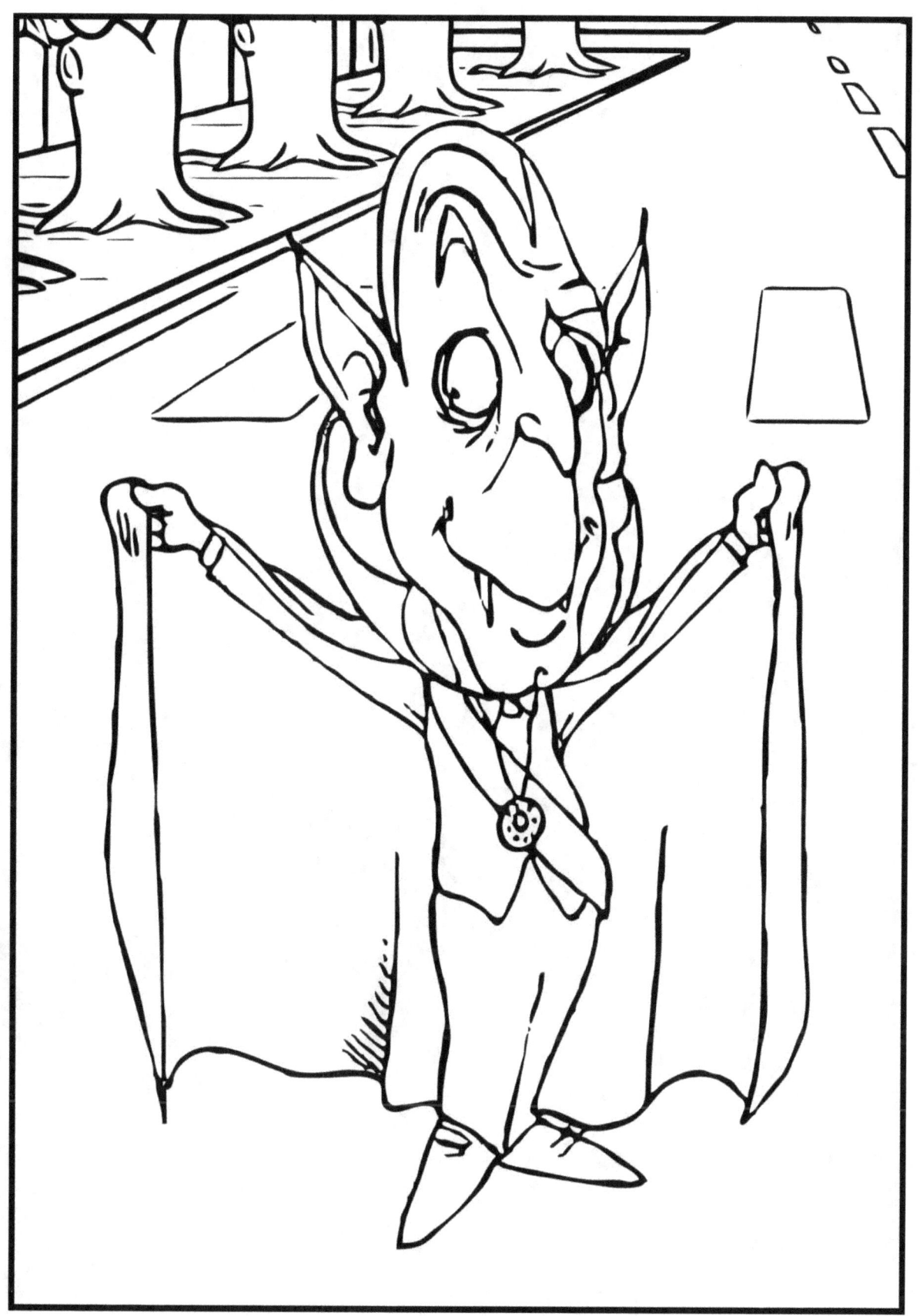

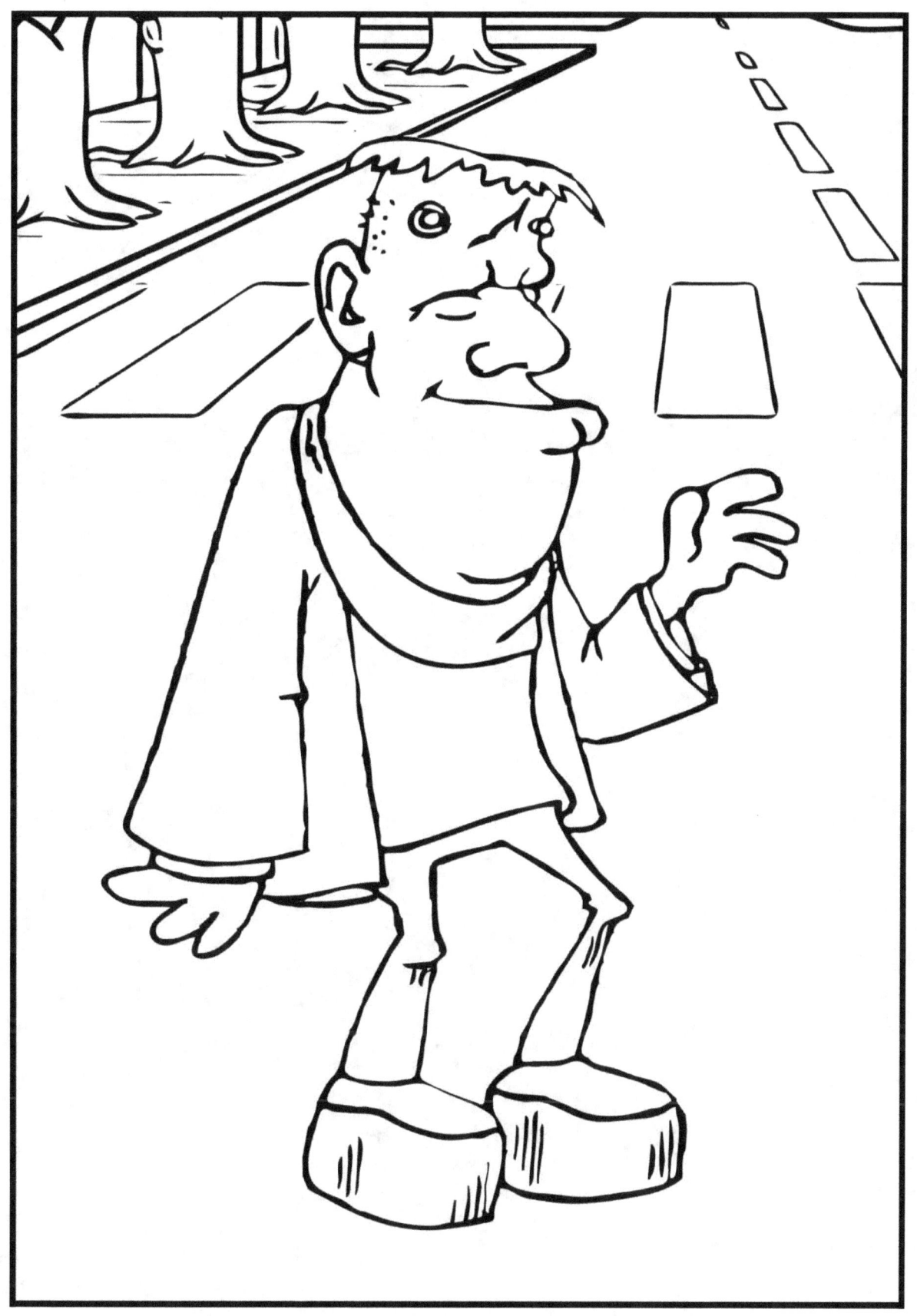

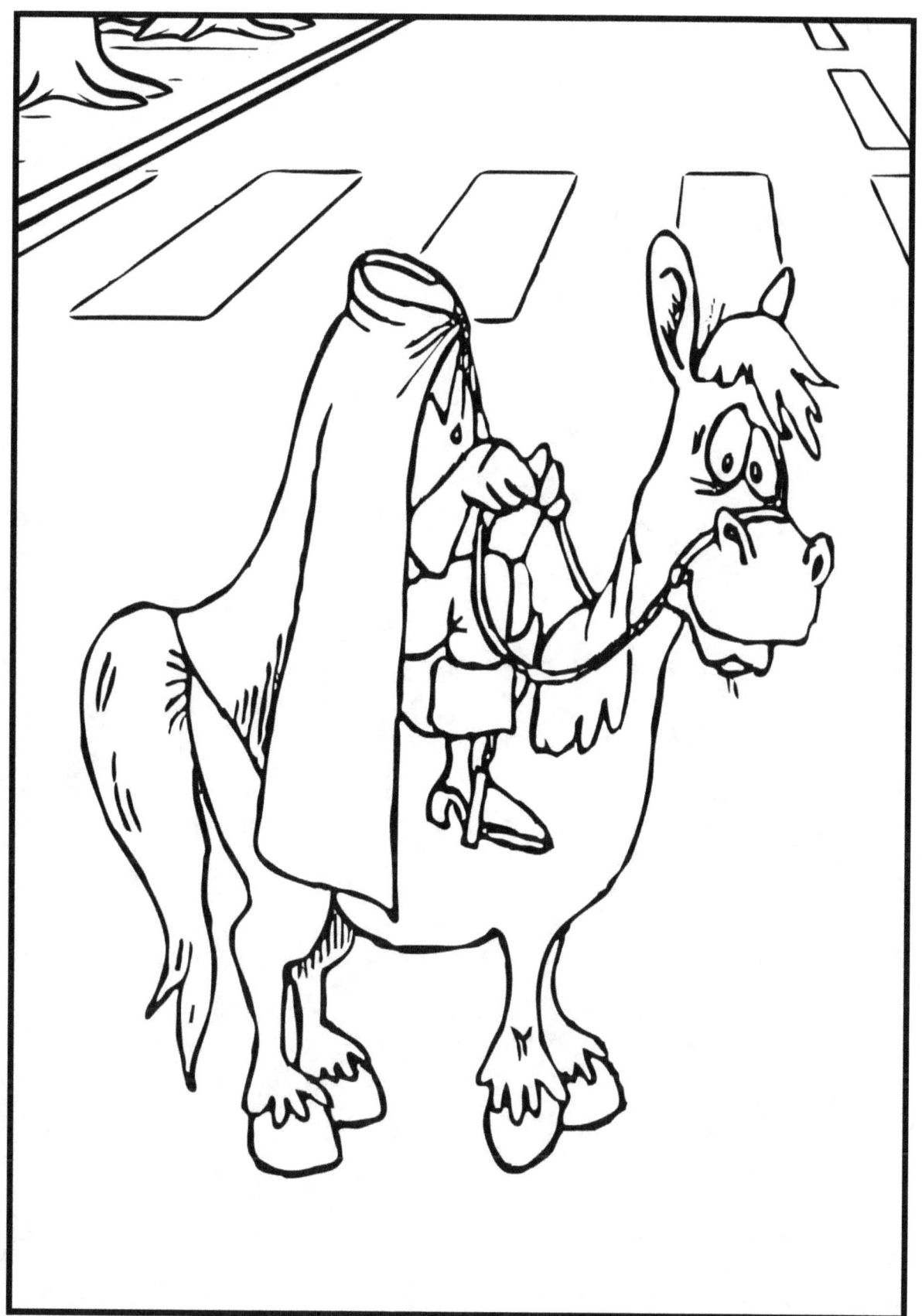

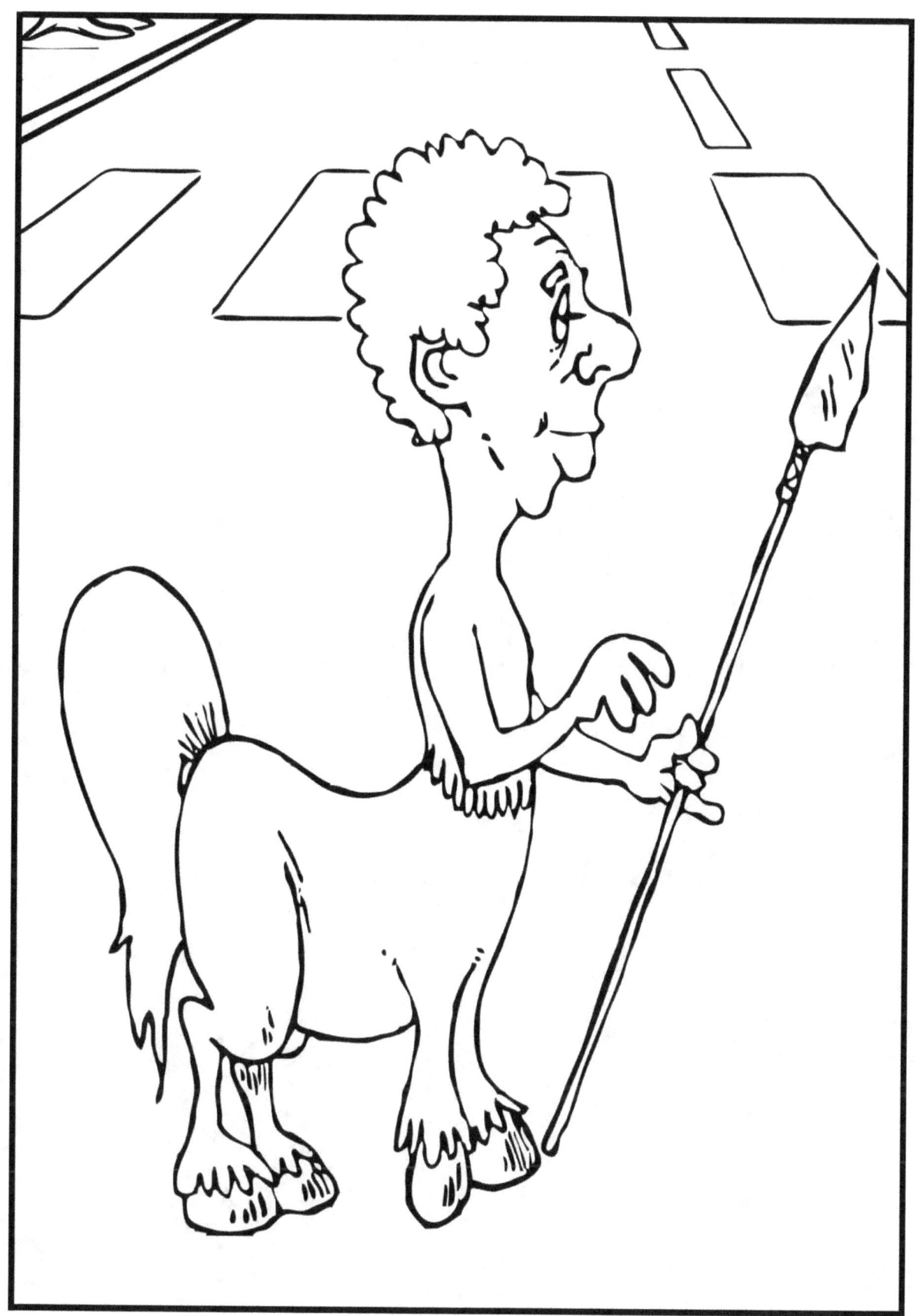

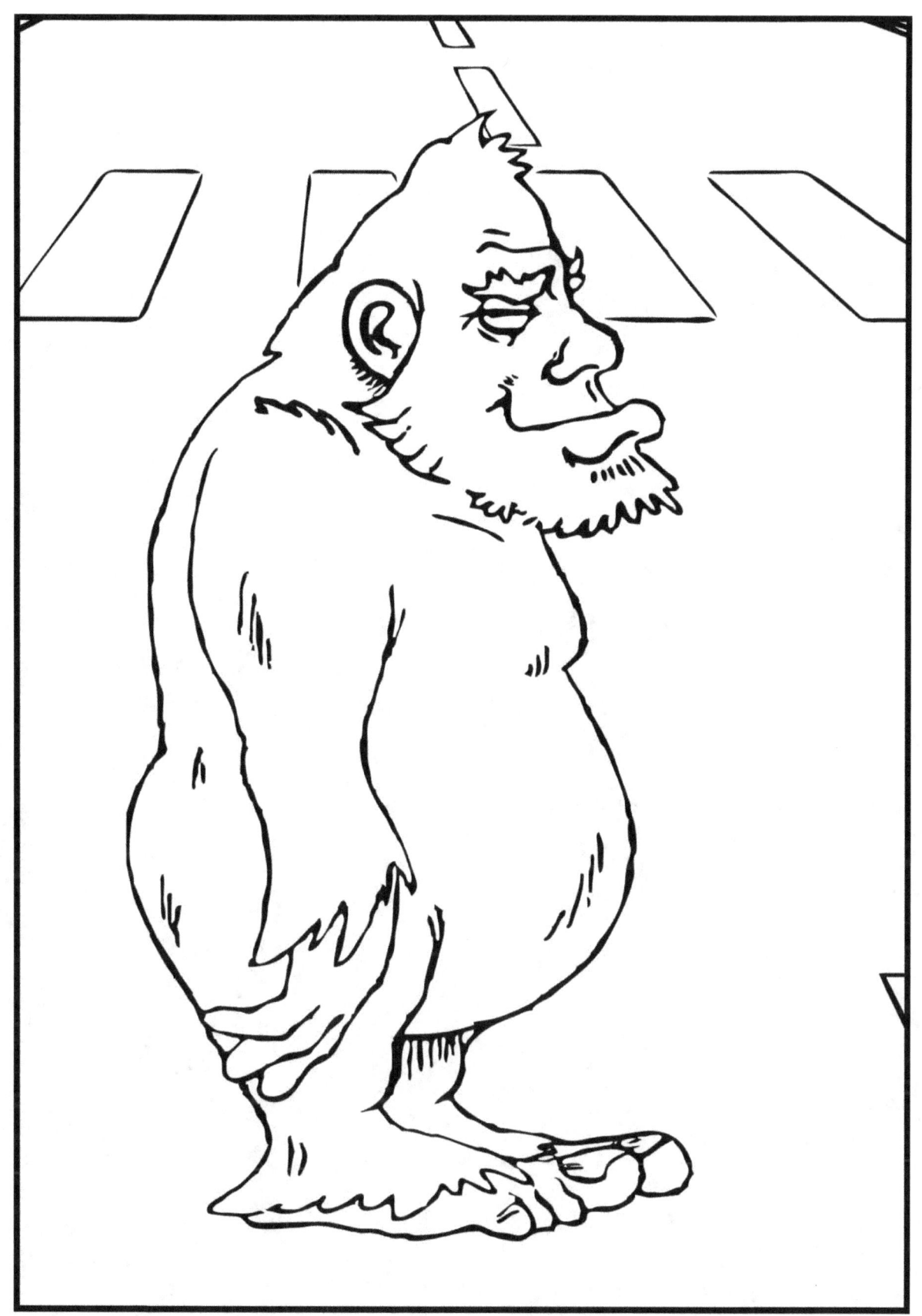

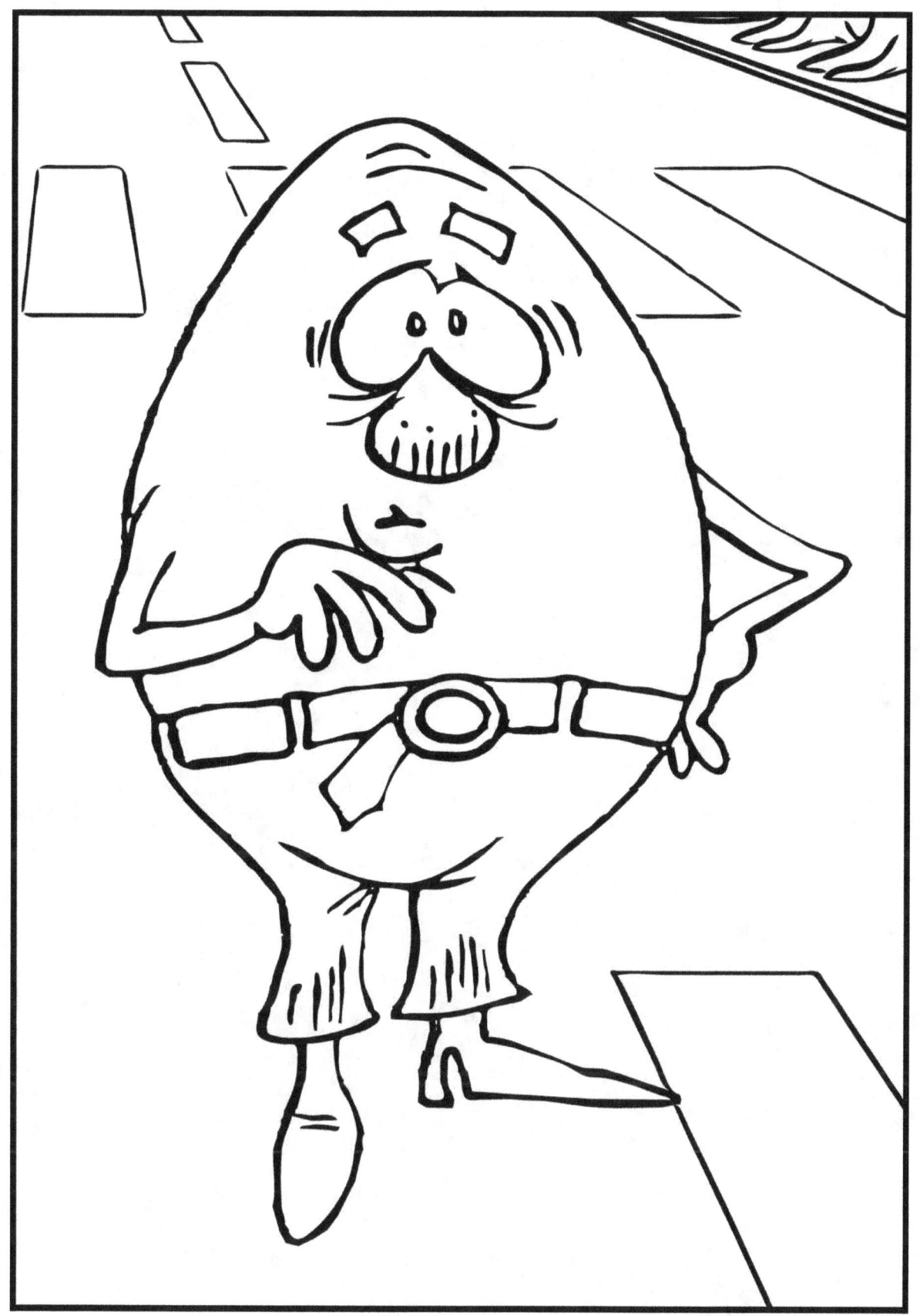

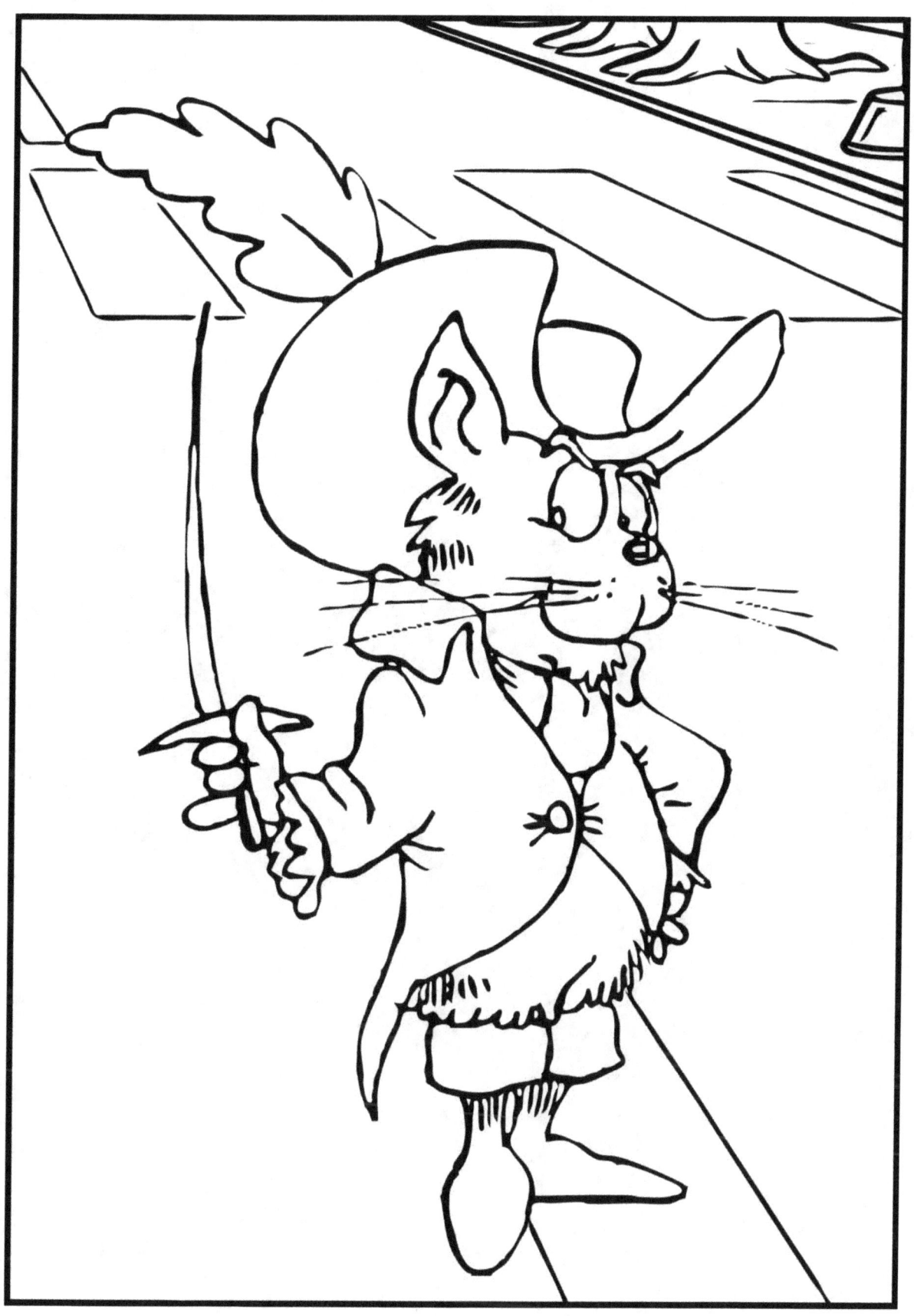

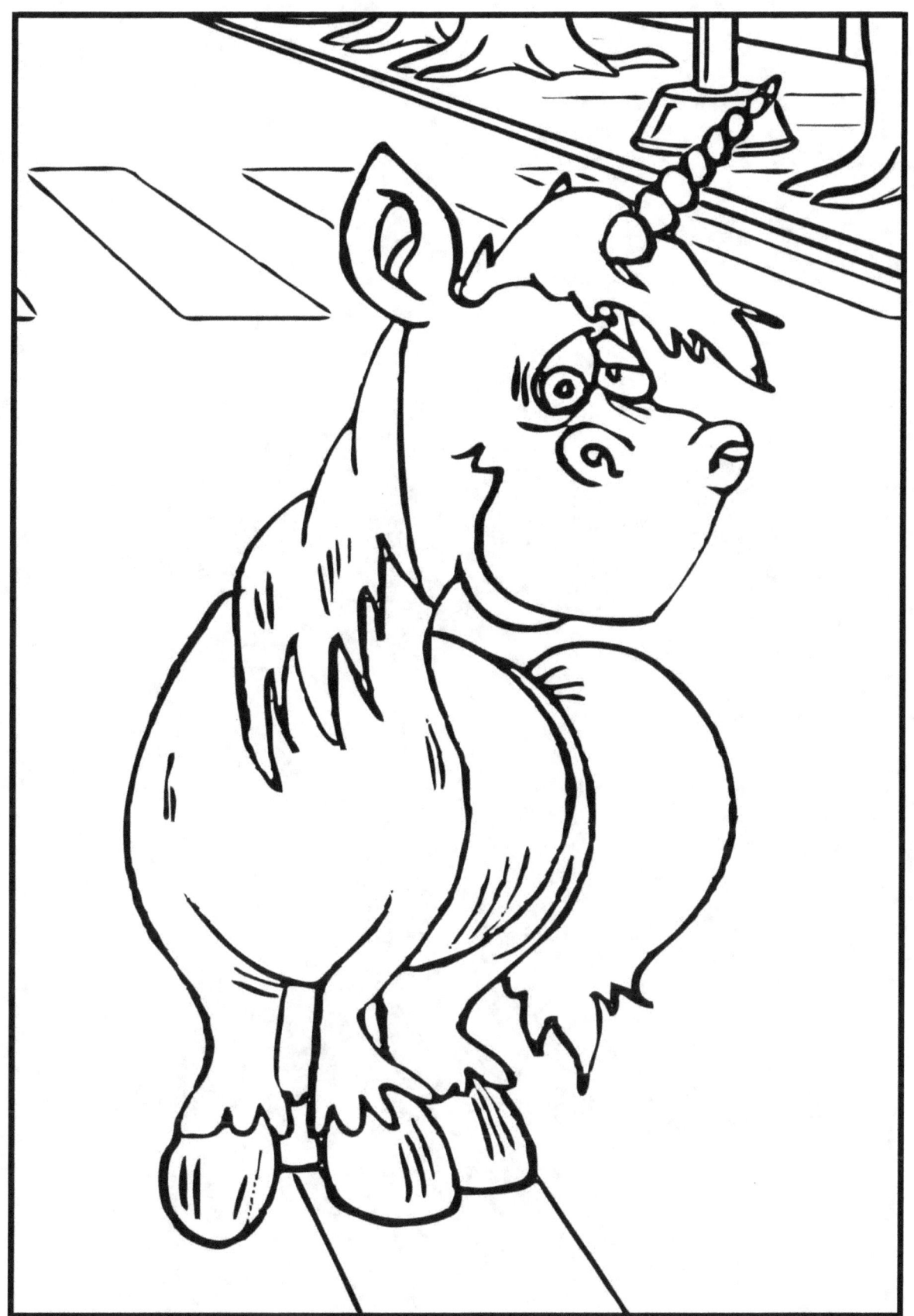

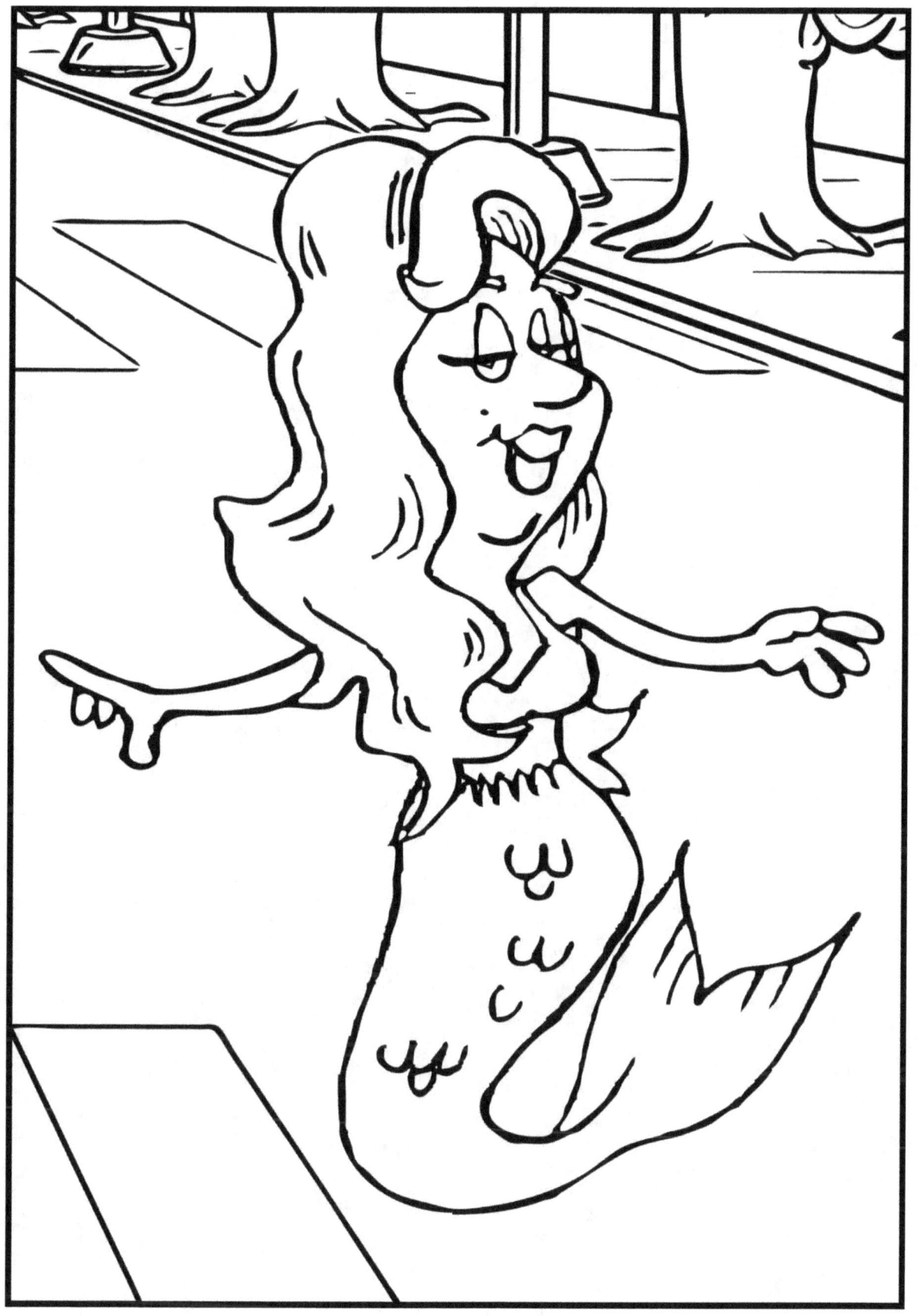

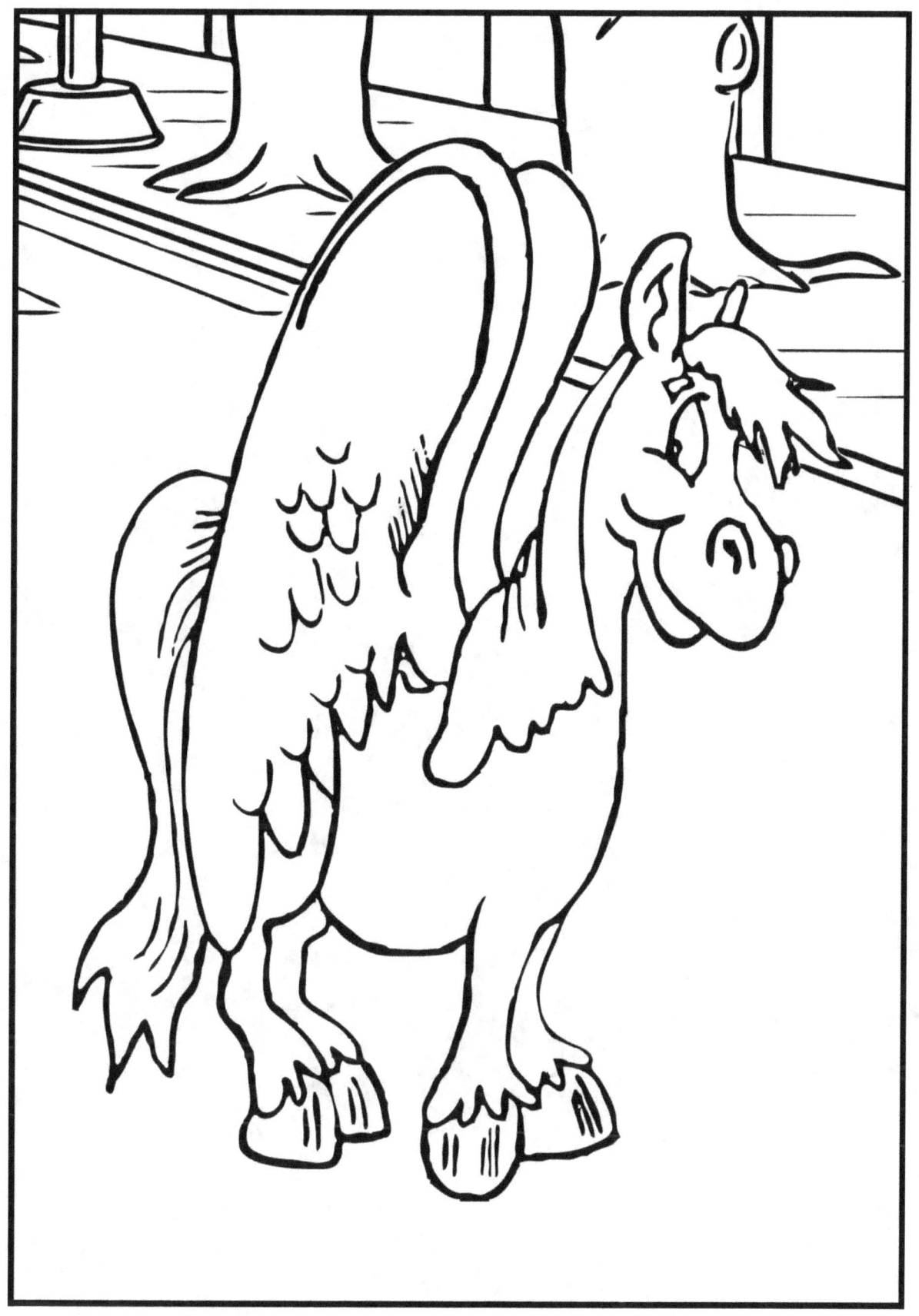

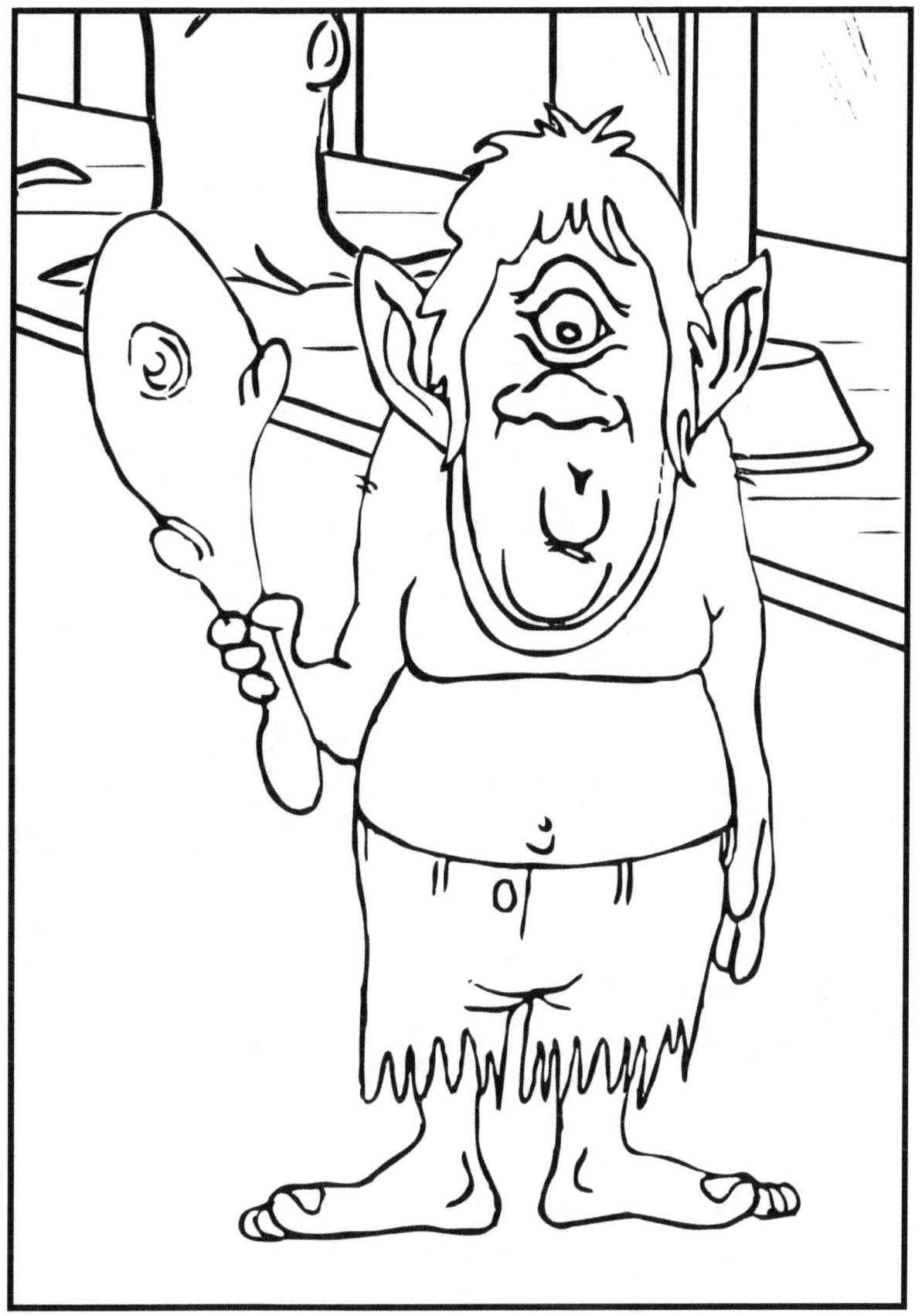

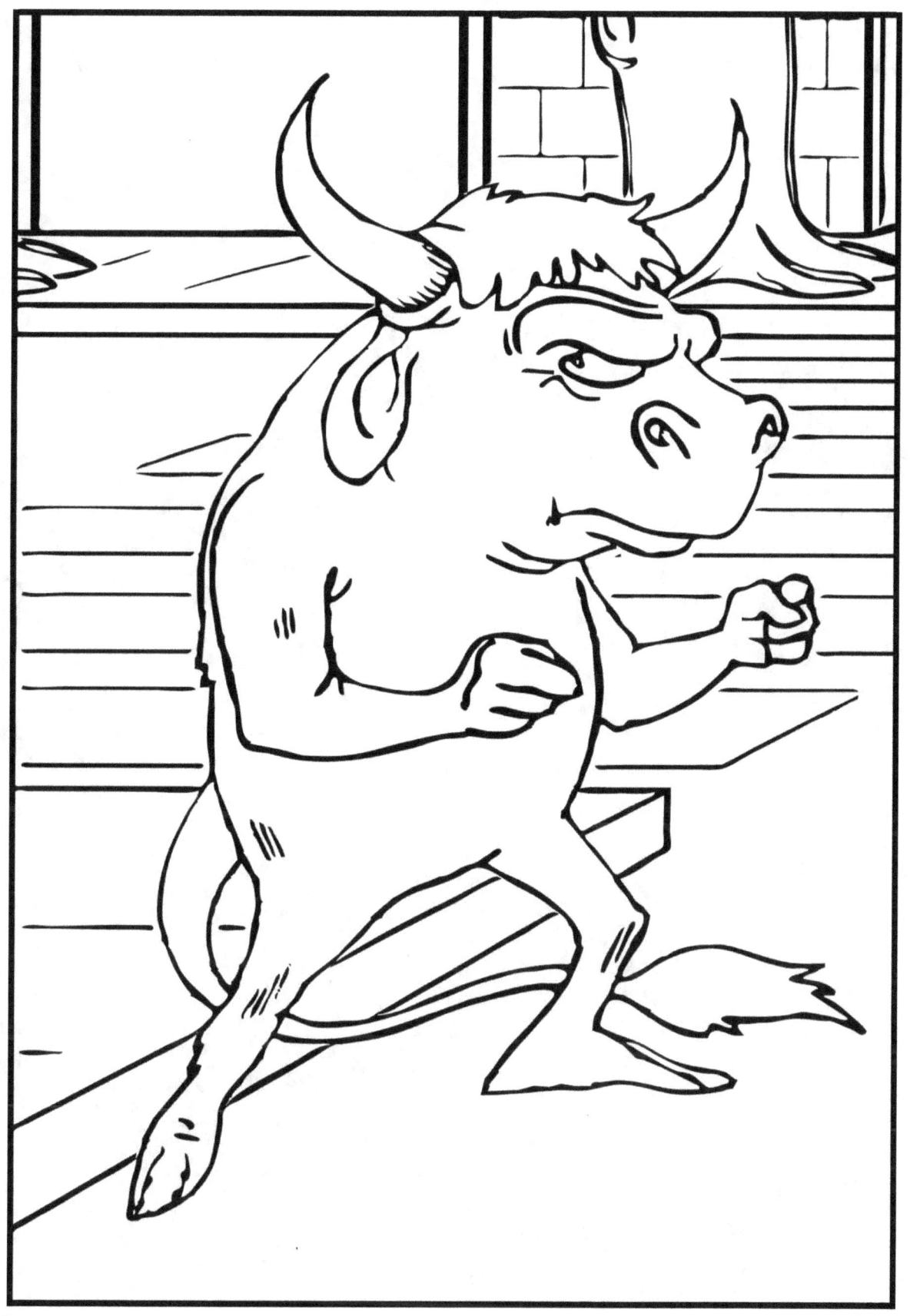

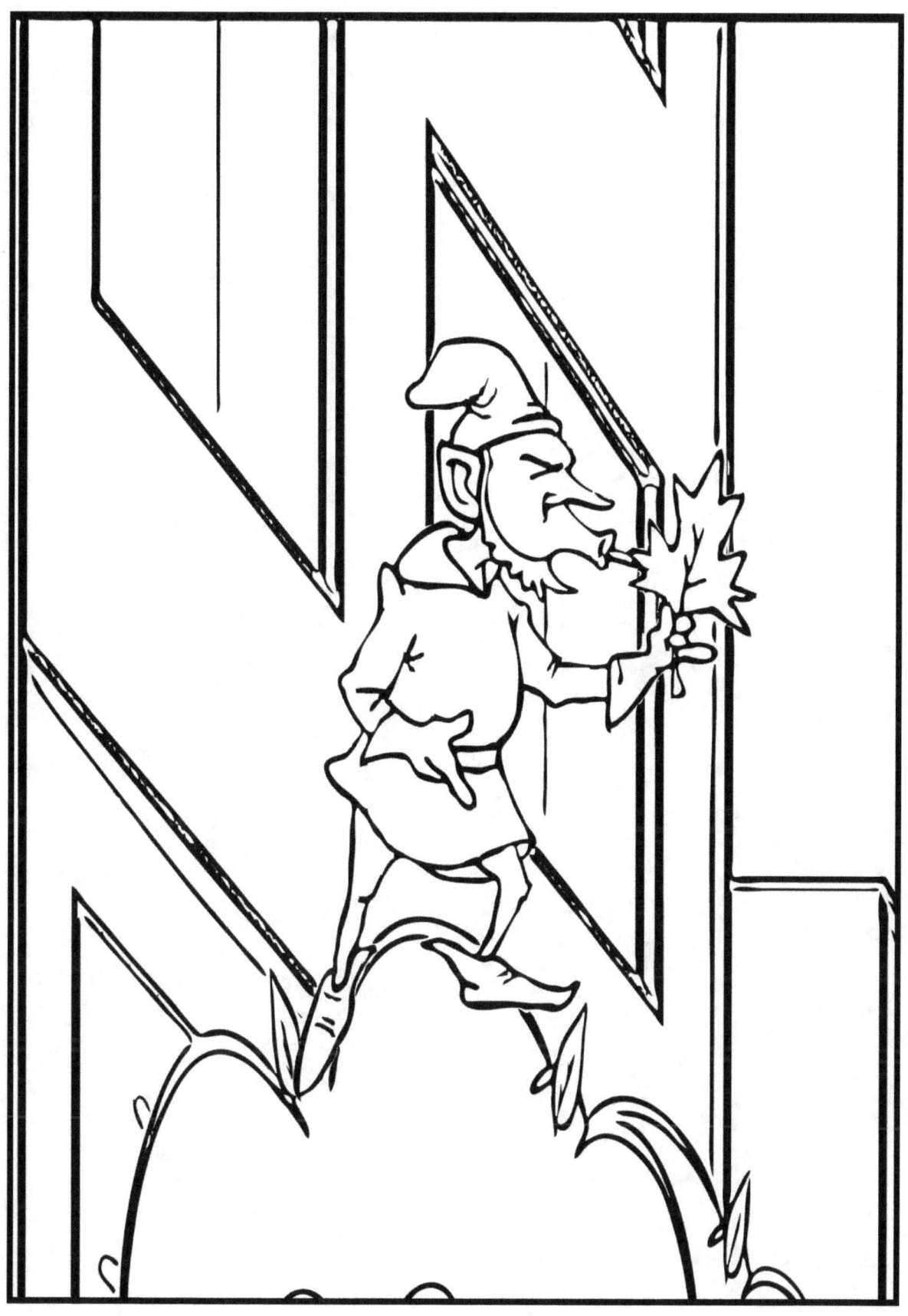

Copyright © 2015 Medieval Coloring

All Rights Reserved Worldwide

MEDIEVAL
Coloring Book

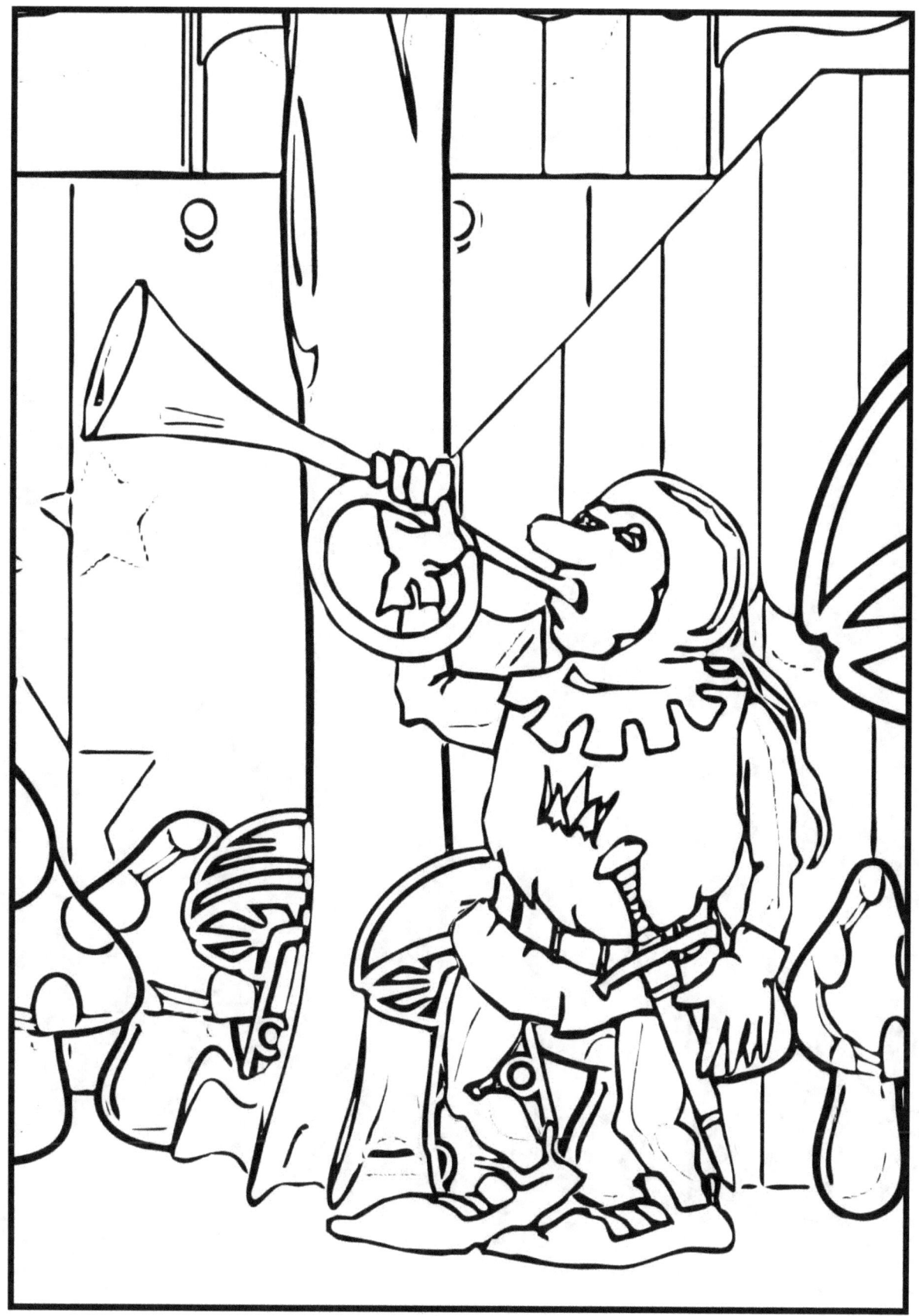

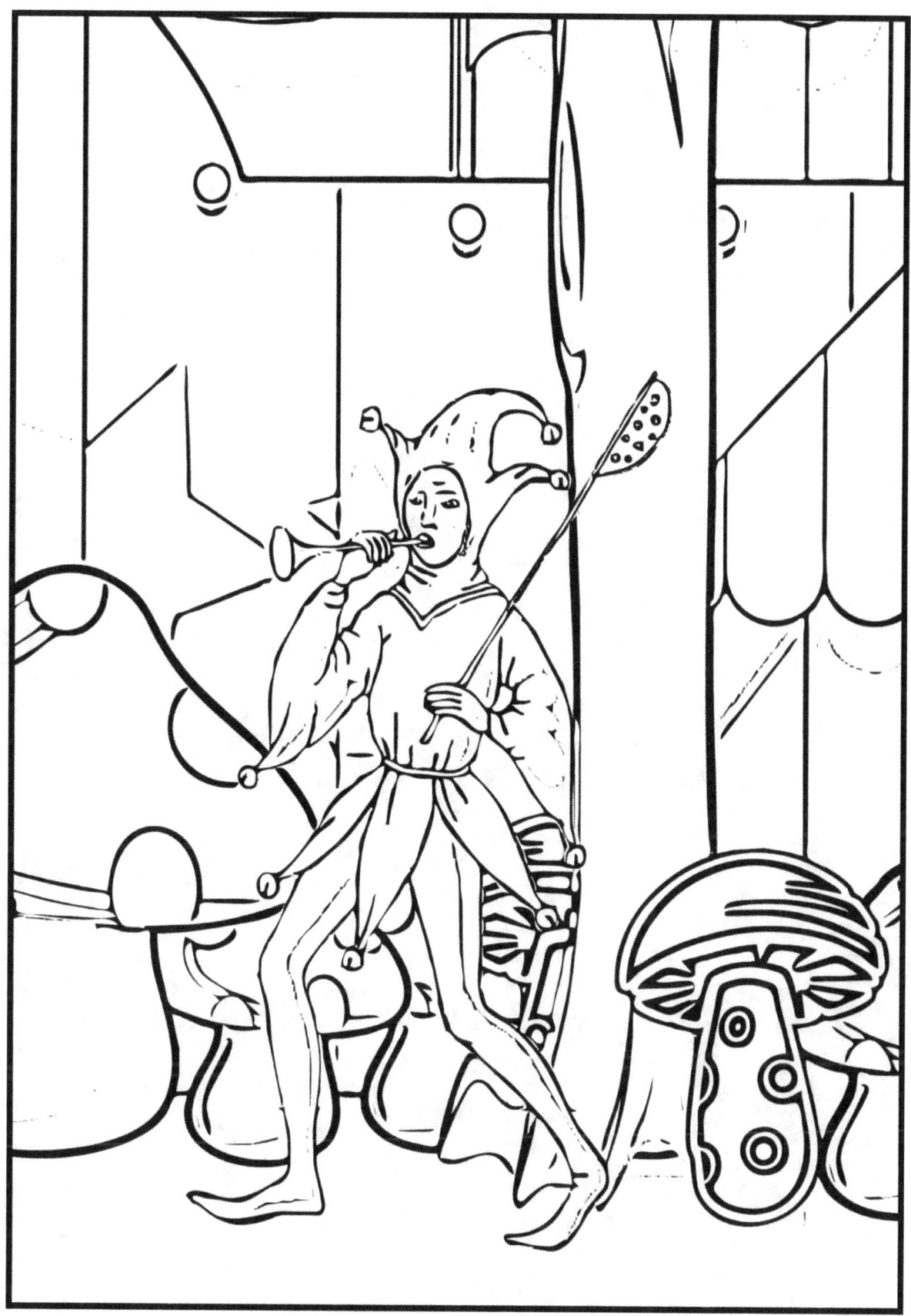

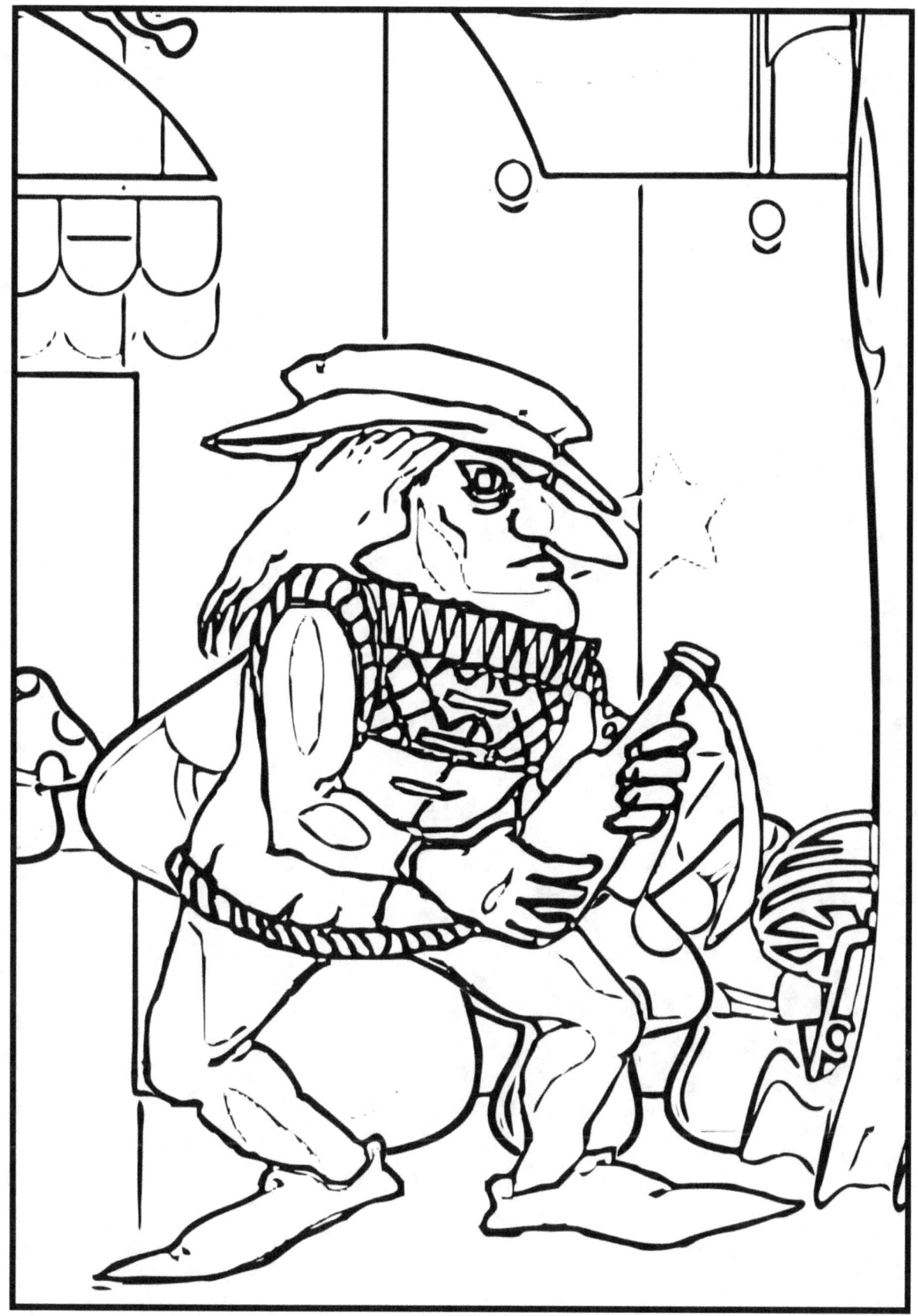

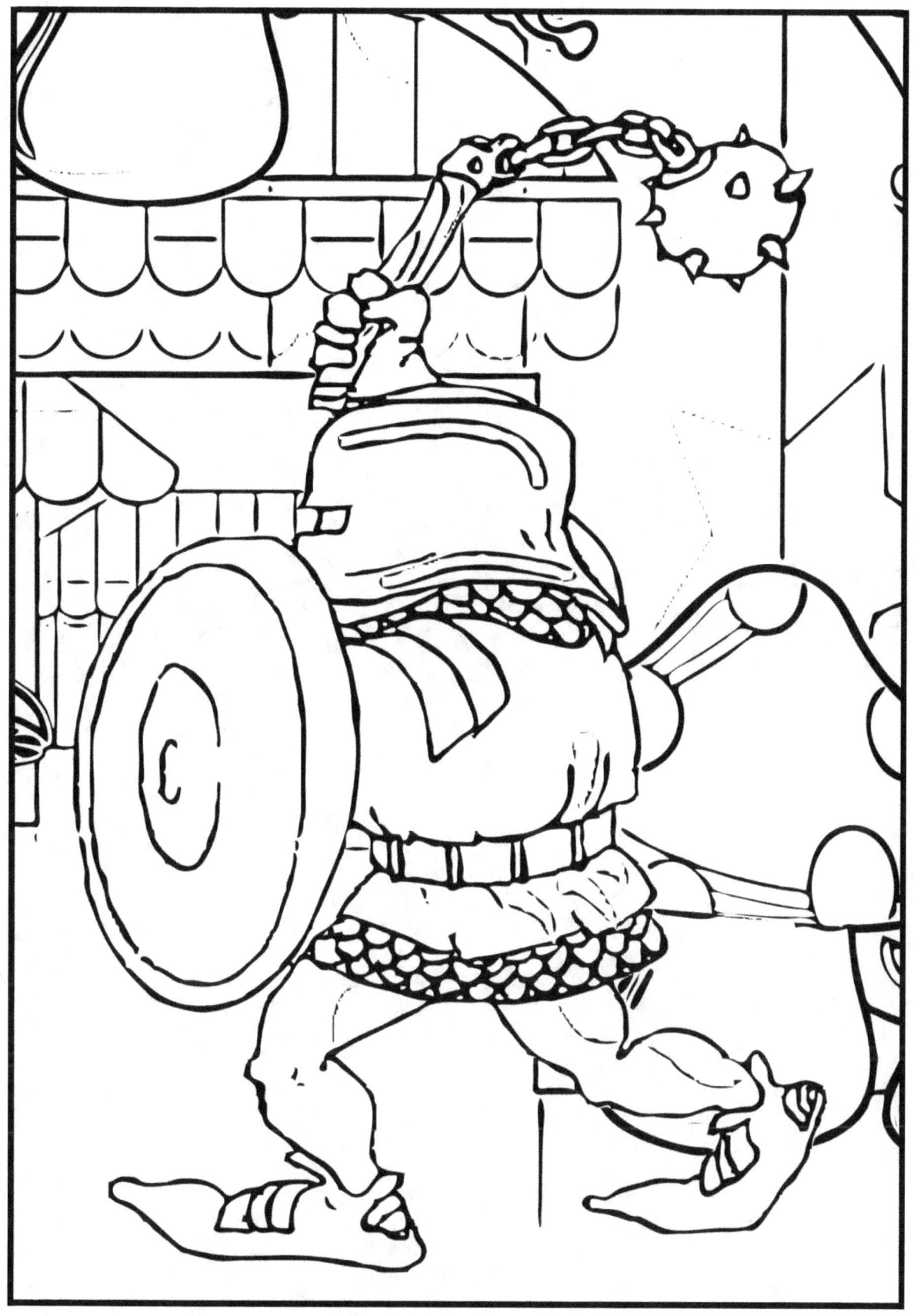

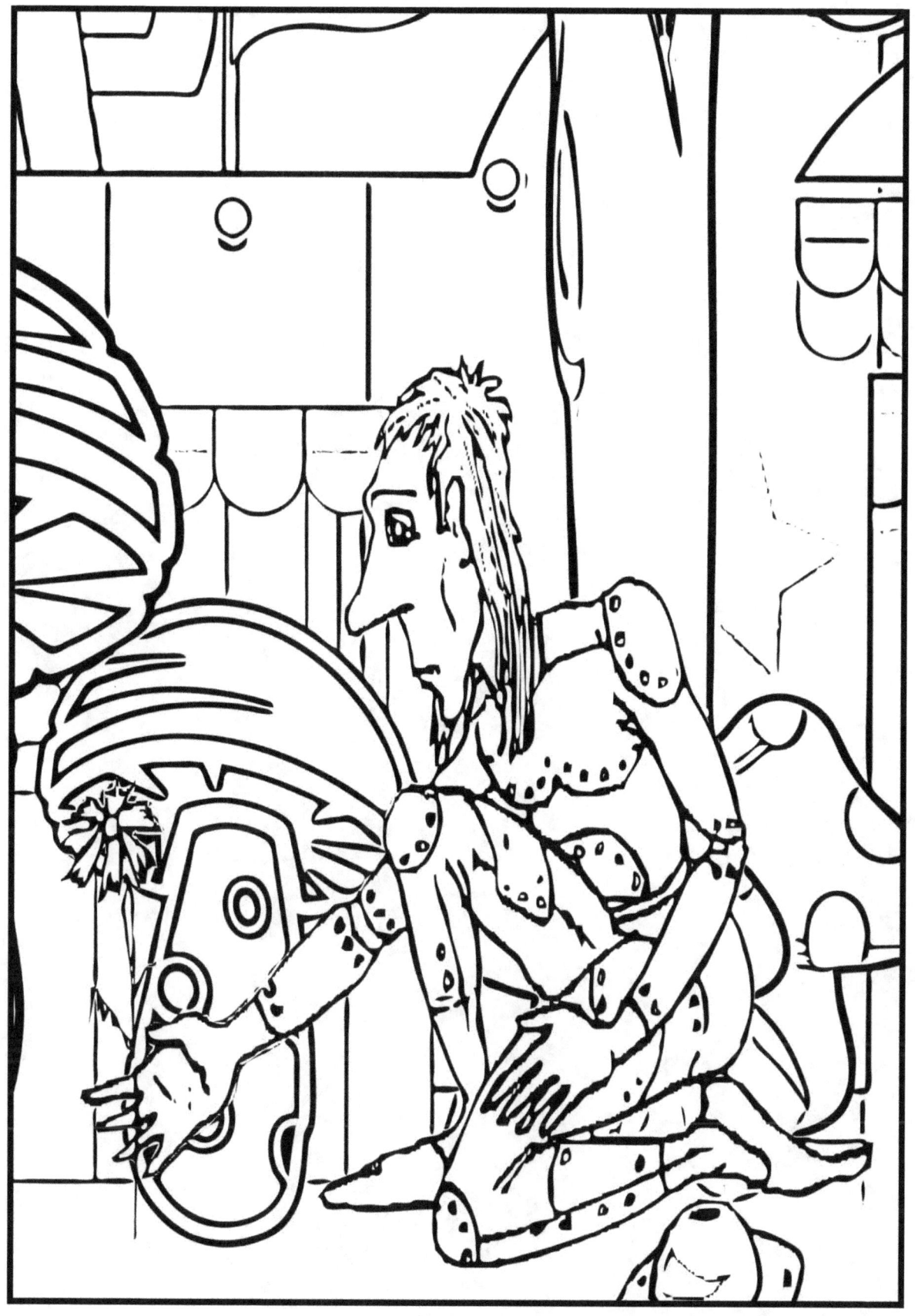

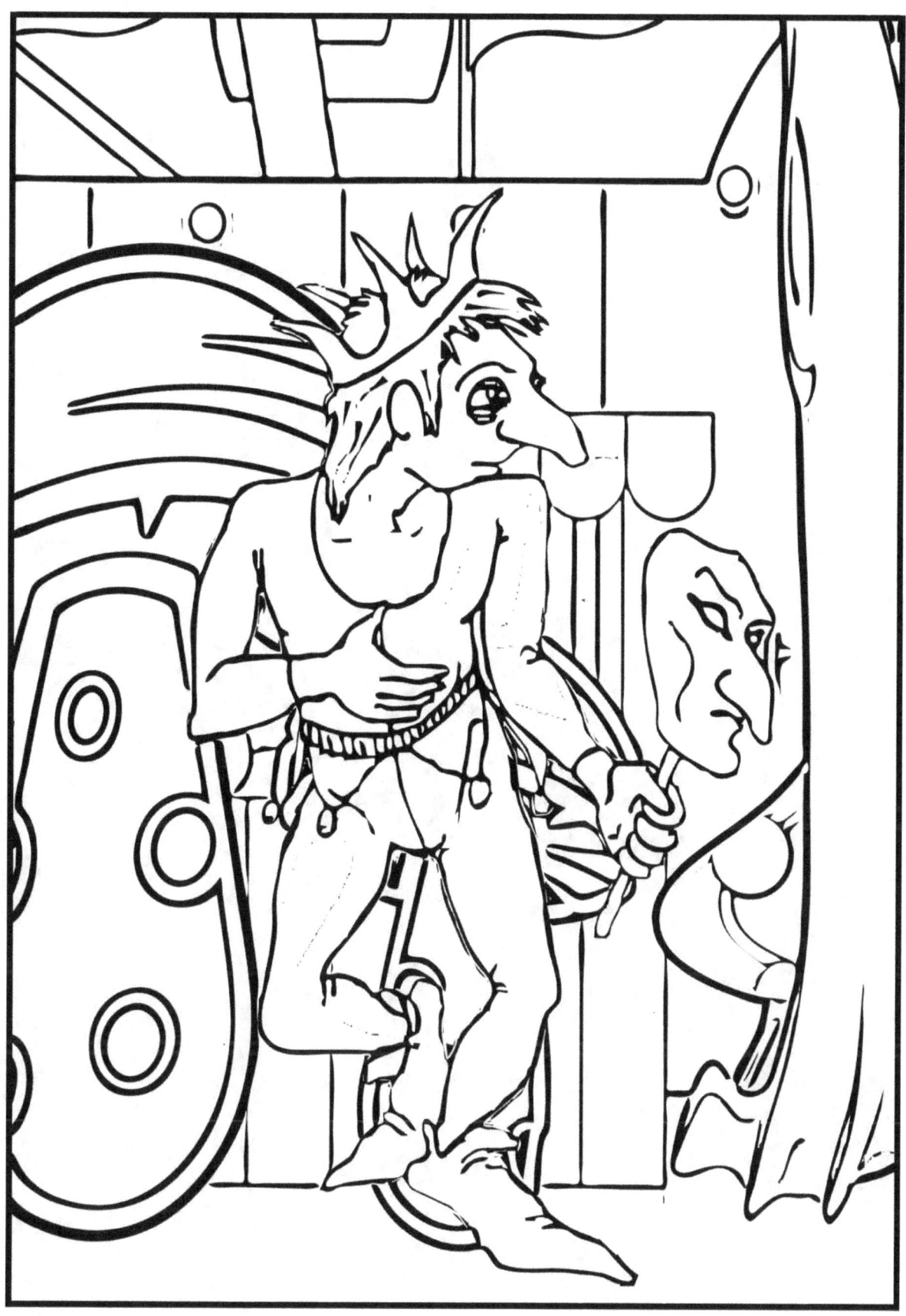

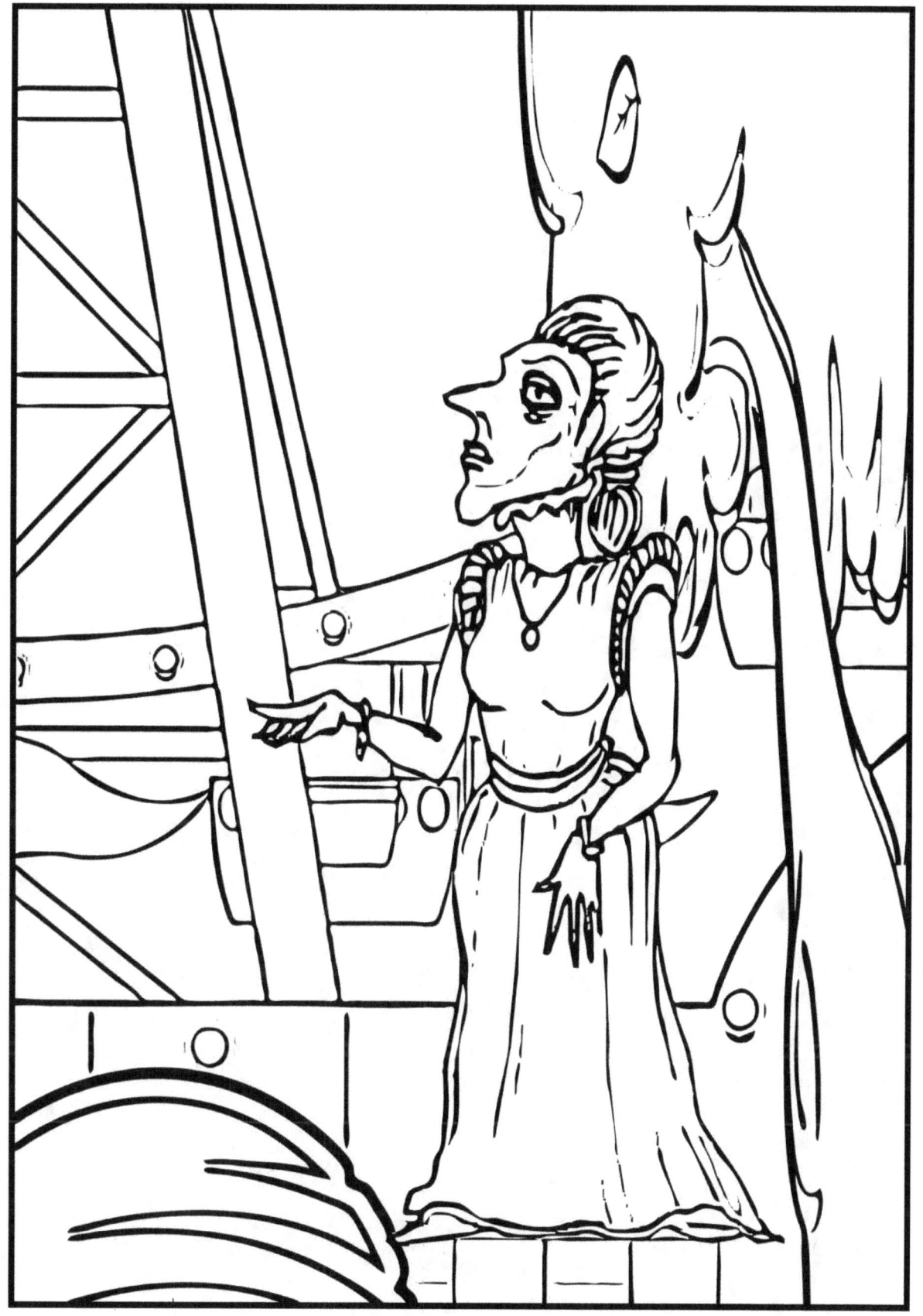

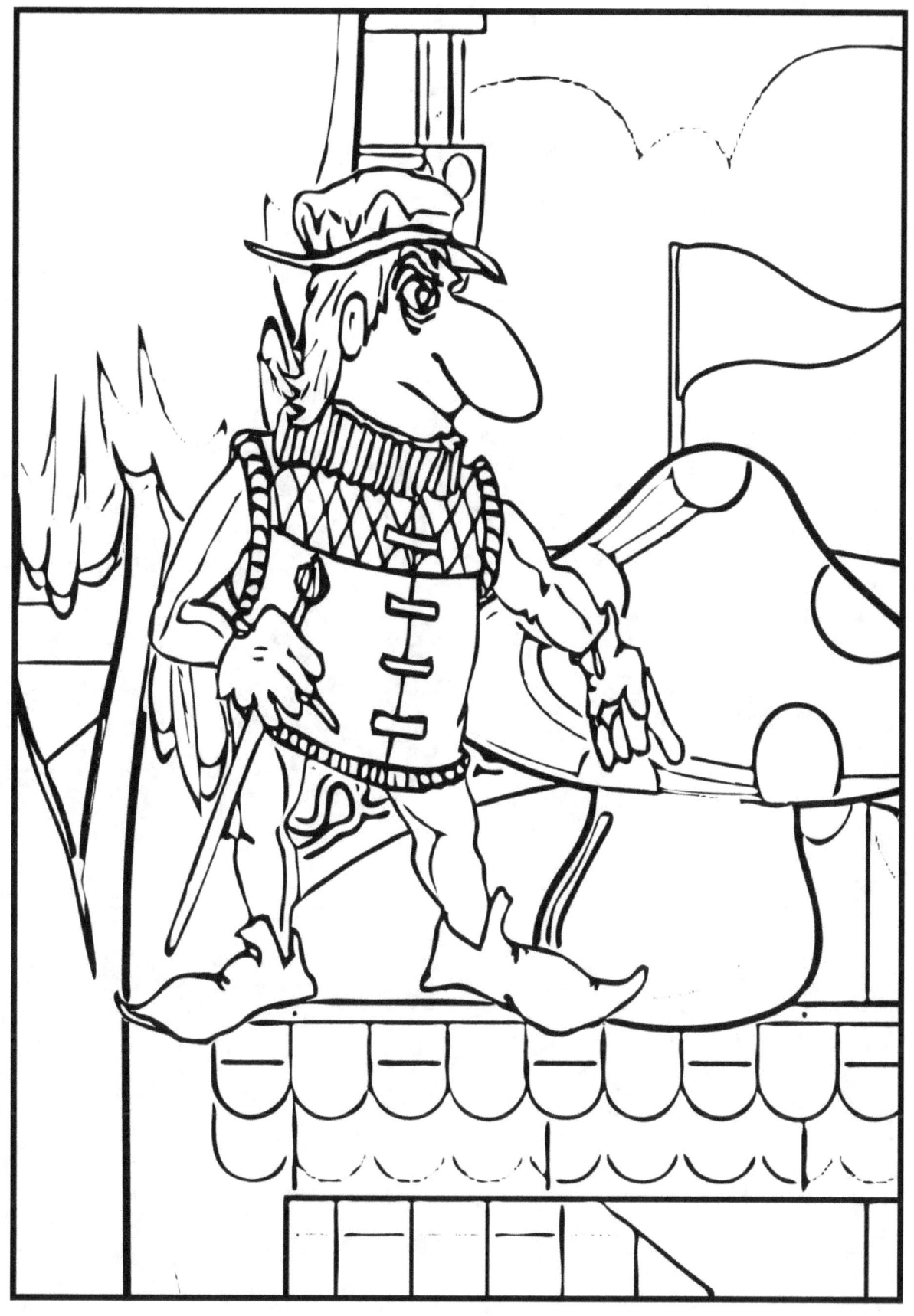

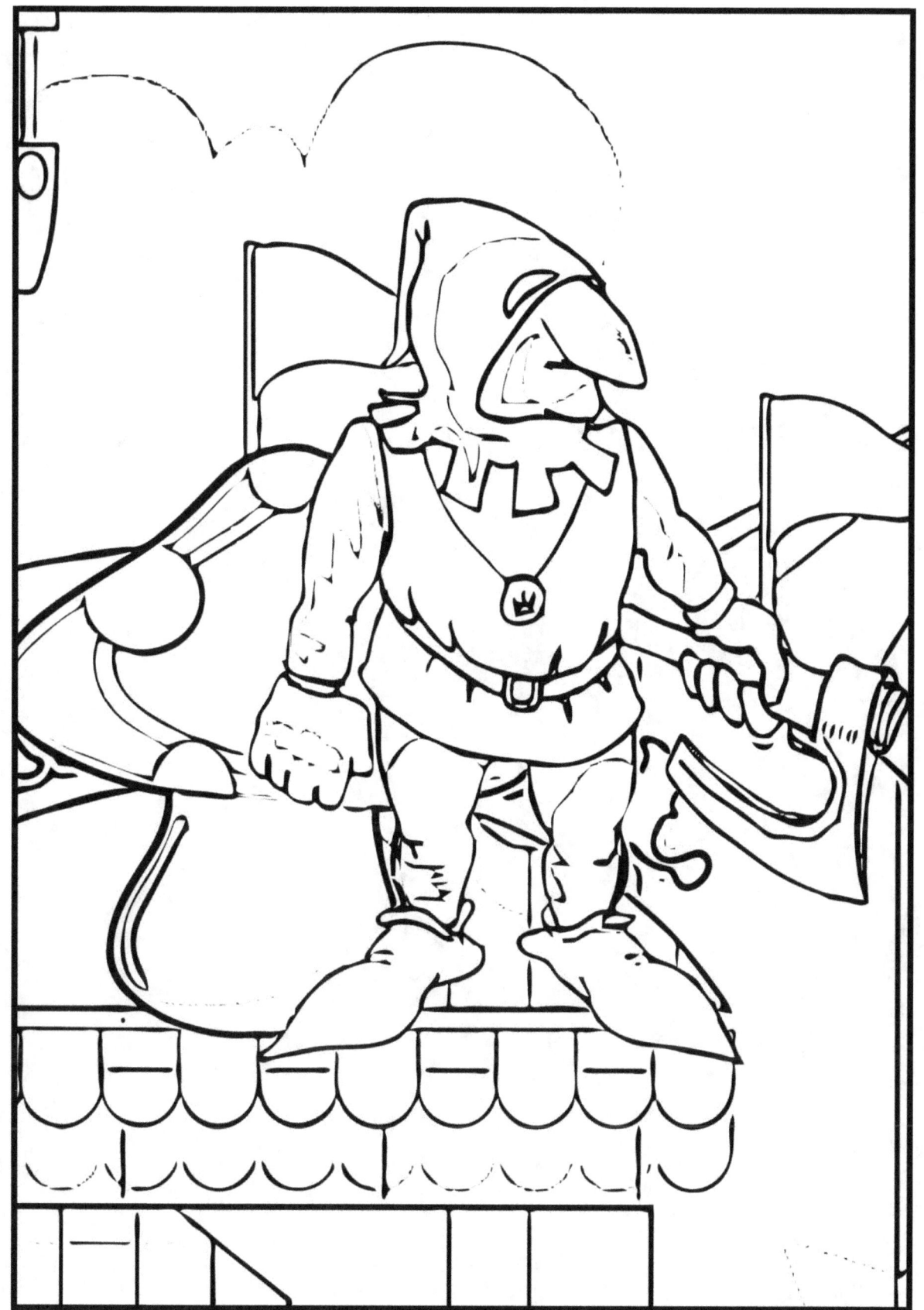

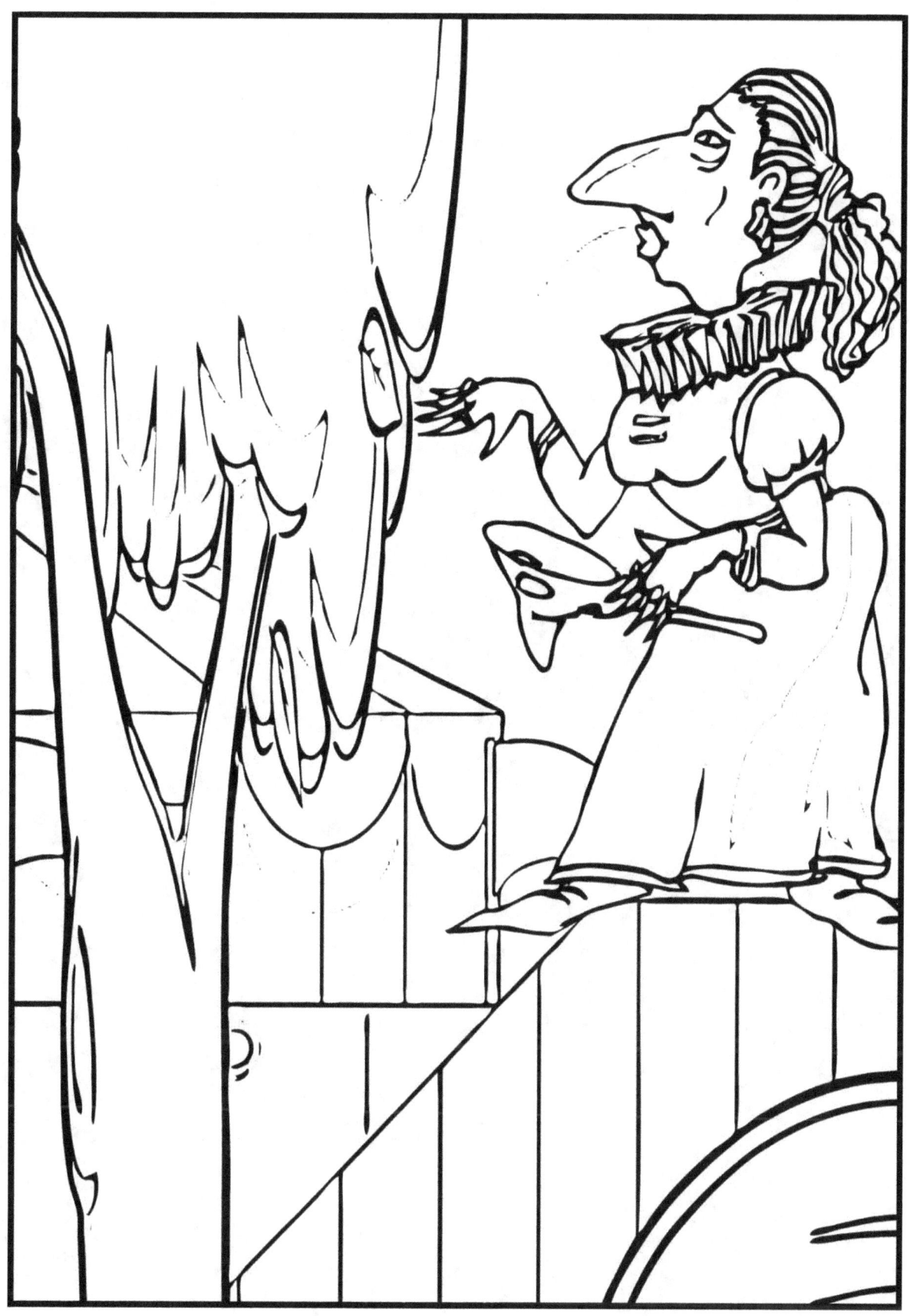

www.ingramcontent.com/pod-product-compliance
Lightning Source LLC
Chambersburg PA
CBHW081209180526
45170CB00006B/2271